Disclaimer: While all attempts have been made to provide effective, verifiable information in this Book, neither the Author nor Publisher assumes any responsibility for errors, inaccuracies, or omissions. Any slights of people or organizations are unintentional. **ALL RIGHTS RESERVED.** Copyright 2017 Ralph Jones

Hope You Enjoy
Coloring Book Of Mushrooms
By Ralph Jones

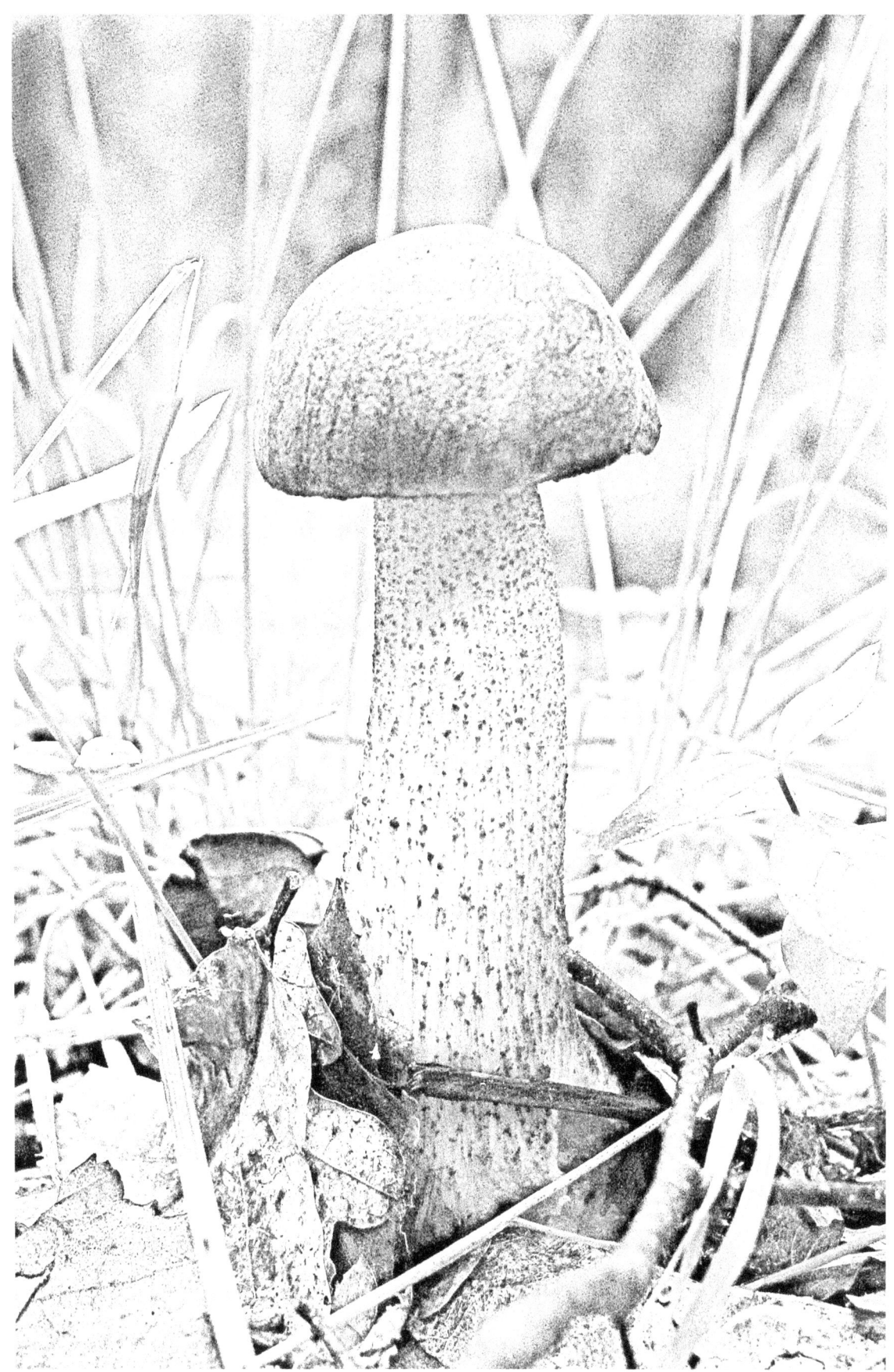

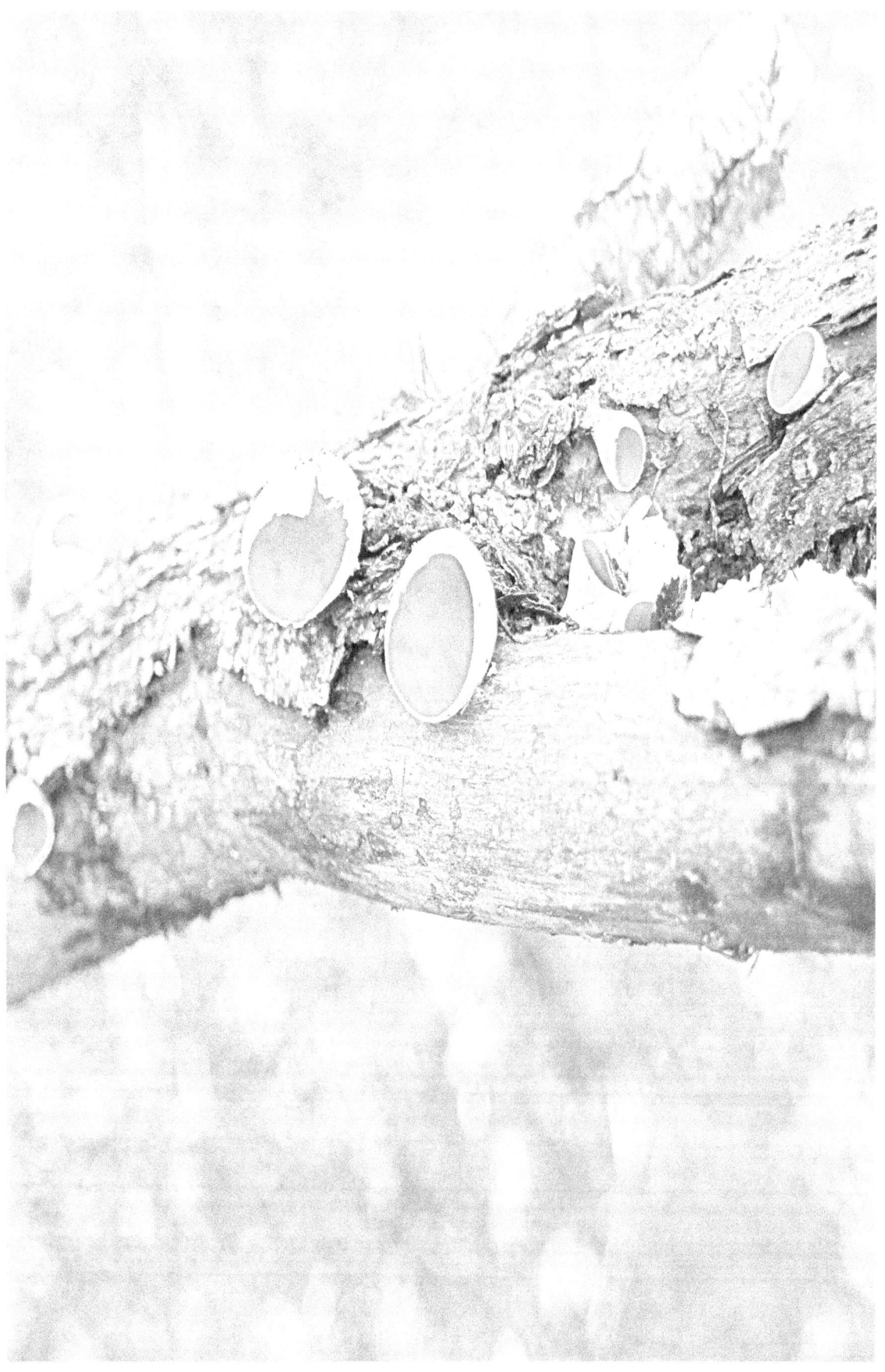

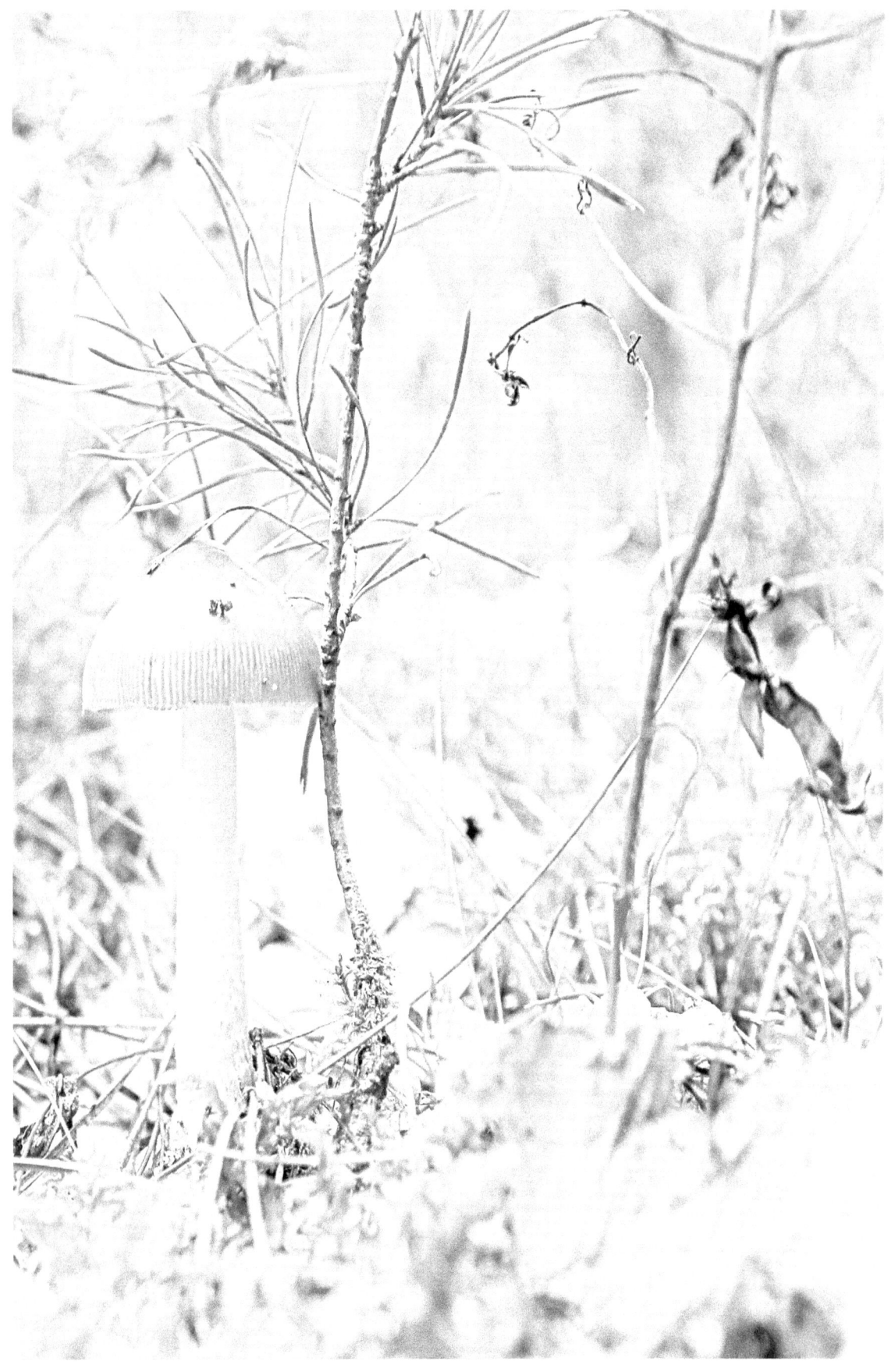

Thanks for reading my book, PLEASE LEAVE A REVIEW.

Links to my other books...
My author page

https://www.amazon.com/Ralph-Jones/e/B00SKPXQZS

www.ingramcontent.com/pod-product-compliance
Lightning Source LLC
Chambersburg PA
CBHW081319180526
45170CB00007B/2774